Dig Photography For Beginners:

Photography Essentials Basics Lessons Course, Master Photography Art and Start Taking Better Pictures

By

Angela Pierce

Table of Contents

Digital Photography For Beginners: Photography
Essentials Basics Lessons Course, Master Photography
Art and Start Taking Better Pictures

By Angela Pierce

© Copyright 2015 Angela Pierce

First Published, 2015

Printed in the United States of America

Introduction

A career as a doctor, an engineer, or perhaps a journalist would sit well with most old folks. Talking of being a professional photographer would be unruly and most definitely unexpected. Or will it be? Over a couple of years, the professional field has evolved from the mainstream single-minded channel it was into a broader more admissive plain.

As technology advanced, the definition of the word career changed too. More and more job opportunities sprang up giving people the ability to either improvise or carve their own path where none existed before. Of all these mushrooming careers, the most notable is digital photography. This is a far cry from what you would do with your fancy smartphone camera. It is a professional arena that needs a perfect understanding of both the tools and rules of the game.

Chapter 1. What Is Digital Photography

You could dismiss digital photography as any other modern time phrase that tends to attach digital as a prefix. We could admit that times have changed and let it lie, or we could take a more objective approach and try understanding what digital photography is all about.

A simple definition would coin it as the taking or manipulation of photographs that are stored as digital files. You can take the picture directly by the use of a digital camera, capture a frame from a video or scan a photograph. It does not matter, provided the image you are dealing with is in digital form.

The master and primary tool of the digital world is the digital camera. It uses arrays of electronic photo detectors in order to the lens to focus of what to capture. The image is then stored on a memory card on the digital camera. It does not use the photographic film, as it was common with the prior photography. While on the memory card, the image can be transferred to a computer or any other digital device

This, in essence, creates the main separation from analogue photography and digital photography. The only way in which you could process a photographic film was by printing it. With digital photographs, you can copy them to other storage devices, manipulate or enhance them and if possible combine a couple of images to create a mash up.

The digital photographs are represented as bit maps. While in this format, the photograph can be edited as you please. You can add a number of effects by use of image enhancing software that we shall be looking at later on. These effects are meant to enhance its look and make it more appealing.

Chapter 2. The Difference in Resolution

Compared to the film photographs, the digital photographs come with a slightly lower resolution. This is not to mean that they are of poor quality because you will hardly note the difference when placed side by side. Furthermore, the low resolution can be attributed to the fact that the digital photos are mainly used on the wild wide web. The low resolution makes it easy for everyone to see it thru internet and to download them.

The popularity of digital photography has risen fast and steady over the years. Major companies like Kodak and Nikon have even opted not to produce or sell the film cameras to developed countries. This type of photography has affected the industry in a very big way. There are as many gains as there are losses. The lose come in the form of certain complementary companies having to close shop or down size the number of workers.

Chapter 3. It Takes a Camera and a Photographer to Make an Awesome Pic

Contrary to popular belief, a higher number of mega pixel does not out rightly equal to a great picture. It takes time, practice and dedication. When in case of latest model of digital camera and you wanted to buy it will be meaningless if you do not have the expertise to use the camera.

What this means is that it is the photographer who makes good photography and not the camera. If it was to be divided into percentages, the photographer would take 70% while the camera takes the 30%. It is not uncommon to find bad pictures taken by a state of the art camera and breath-taking photos taken by use of a mobile camera phone with less mega pixels.

There are many file formats for digital photography. JPEG just happens to be the most convenient and common. It enables compression of the files, which makes transmission on the internet faster. Other formats include TIFF and Adobe Photoshop PSD format.

During production, digital photography may be faster and cheap but it is not easy at all. Coming up with a quality product requires great expertise.

Chapter 4. Simple Things Every Digital Photographer Must Know

A picture is worth a thousand words. This is true. What we forget to add is that a bad picture will not tell the same story as a good picture. Pictures freeze moments. How well that can be achieved depends on how well you have mastered your art.

It is all about the light

The amount of light could either make your picture great or destroy it completely. Mastering the art of balancing the light is what separates a pro from a novice. This is the reason why most photographers will schedule their photo shoots in case there is too much sunlight. You will find majority of photographers preferring to take their photos during the early morning hours and late in the evening when the sun is setting.

Direct sunlight will always result in production of sharp shadows and it also spoils the picture. As a digital photographer, you need to understand how to position yourself in a way that the direct sunlight is no longer a hindrance. Knowing how to use the flash could make

this very easy. In cases where the background is already bright, the flash helps in lighting the foreground thus eliminating the shadows.

Know your camera

There is no need of having a fancy digital camera that you hardly know anything about. Digital cameras continue to be produced by the day. There is always a new invention with every passing year. The difference is always in the features offered by the camera. These features if utilized properly will make photo shooting for you very easy.

A feature such as autofocus is invaluable once you understand how it works. It will help you do away with instances where backgrounds of picture are more profound than the subject. This and many other features may just happen to be the magic that epic pictures are made of.

Whenever you buy a new digital camera, do not just throw away the manual unless you have read and understood most of it. Ensure that you try out the instructions on the manual. It will take some time before you finish going through the manual. Don't rush. Take your time to do it right.

Move close enough

The little details are what make up a good picture. Moving close enough to your subject will enable you to capture every single detail.

Rule of thirds

Apparently, not even the latest of technologies could write off this ancient technique. This technique entails dividing your focus area into thirds. While looking into the lens, you will then place the subject around the area where the fractions intersect. When you take the picture, everything will just turn out as it is supposed to. The background, foreground, and the object will all be perfect. This principle should serve as a guiding tool when taking your pictures but should not be used almost every single time.

Chapter 5. Choosing Your Cameras

As we had seen earlier, a top-notch cameras does not guarantee high quality pictures. Two people can possess the same camera but the resultant quality of pictures end up being very different. The camera does not shoot itself. However, it is always worth to have a good camera if you can afford it. Before making that choice there are several things that you will need to consider.

What do you need?

The world of photography is very diverse. Many photographers specialize in many different fields. With the diverse needs come different types of digital cameras to satisfy those needs. You need to know the type of photography you want to venture into. It could be portraits, landscapes, sports, or macro. The type of environment you will be operating in also matters in addition to the kind of features you want the camera to have. Lastly, your level of experience has to be considered too. You need to take time to answer the above questions if you are to get your desired type of camera.

DSLR vs Point and Shoot

The point and shoot camera will be the best choice if you are just a novice who is starting to explore the world of photography. It is not complicated like the DSLR and it is also affordable. The DSLR are better qualities which require proper care and maintenance. They are bigger and heavier than the point and shoot cameras. The good thing with the DSLR is that they have the largest image sensors, fast focus speeds, and wide variety of lenses. All these come at a higher price. You will also need the experience to better handle them.

The zoom and big sensor factor

As far as zooming is concerned, you will be presented with the choice of the optical or the digital zoom. Between the two, the optical zoom is a better choice as it producers better quality pictures. The digital zoom has the tendency of enlarging the picture and making it more pixelated. The zoom ratio is important because it determines the angle coverage of your camera. A camera that can cover wide angle shots is better especially for taking family portraits.

These three factors should help narrow down your search to a manageable number. What remains is going out to stores that sell the digital cameras and asked to test them. Eventually, you will be able to get a camera that you feel suits you best. Nikon and canon are two of the leading manufacturers of digital cameras around. Their brands tend to get better reviews from clients.

The flash

Having a flash on your camera is no longer a necessity. It is mandatory. Choosing detachable flash units will help you illuminate each scene appropriately before snapping the shutter. Even though most of the professional photo shoots would include backup lighting, a camera with an on board flash will always take better photos in low light areas than one without.

You however have to remember that having a flash mounted onto your camera does not mean that you should always use it. There are specific occasions when you must never use your flash. For instance, when taking photos including highly reflective surfaces, for instance mirrors or shiny surfaces, using a flash will

reflect more light hence creating a 'burn' effect on the photo.

When taking close-up pics, an active flash bulb will most likely stun the person and make them break the pose. Using secondary lighting is always advised unless you are taking paparazzi pot shots or photographing nature.

Budget

In the end, it will come down to the amount that you are ready to spend on the camera. With the wide variety, you should be able to get a good camera that is within your financial means. Spending large sums of money on a product that only differs from one that is available in terms of megapixels is not a very good idea.

Chapter 6. Knowing Your Camera Lenses

A good DSLR (Digital single lens reflex) will push your skill and finesse beyond the limits. In essence, DSLR camera contains removable lenses meaning that you can always attach the lens you want for different pictures. The basal power of this type of a camera is in the fact that you can always take different pictures in different settings provided you have the right lens.

With this, you do not have to invest in cameras with strong lenses or impressive software processing to cover up for the changes in performance. With a DSLR, you can start simple with the cheapest lenses in the market before moving on to more expensive and impressive lenses.

So far, nothing answers the question at hand. If you can afford to invest in the compact and surprisingly effective cameras in the market that aren't DSLR but can still change lenses, then you might be god to go. Either way, you still must know how to differentiate your lenses and what to consider before buying an add-on lens.

Mount surfaces

Cameras have different mount surfaces. Most brands would love to keep their mount surfaces different from competitors meaning that there are no universal lenses unless you first use an adapter to recalibrate your mount point. Buying your brand's lens is the best way to going around this.

Focal lengths

The kind of photography you engage in should determine your lens' focal length. The focal length determines how much a camera can zoom. It also has an impact on the overall cost of the camera. For normal close up photos like model portraits, you could make do with 50mm or 75mm lenses. However, if you are into nature photographs and want to capture the beauty of that praying mantis without chasing it away, something more menacing like the 300mm lens would be perfect for the job.

Chapter 7. Professional Photo Editing Tools That Will Make Your Photos Look Cooler

The days of doing several retakes to get the perfect picture are long gone. In digital photography, several software tools enable editing of pictures to give it the desirable finish you are looking for. Most of them are available for download at no charge. Each one of them is good in its own right. It depends on what you are looking to achieve. A good photo-editing tool should possess some of the following features.

User interface should be easy to understand and use. It should have as many editing features as possible, organizing capabilities like thumb nail should be included, should have sharing features, and import and export function should be able to handle several if not all formats of pictures.

Photoshop

This is most likely the most favourite among many people. It offers users with a wide range of photo editing features. It may take some time to master it

but once you have perfected your skill, you can do almost anything with the software.

GIMP (GNU image manipulation program)

If there was no Photoshop, there would be GIMP. This software is open source whereby a community of volunteers maintain and improve its features on a daily basis. It is available for both Mac and pc. It is the perfect alternative for Photoshop that is highly priced.

Paint.net

It first came into being as a project design for a college undergraduate student. It was intended to be a free replacement for Microsoft pain. Surprisingly, it went ahead to outdo Microsoft paint in terms of functioning. It also has more improved features. It can actually stand its ground in the face of Photoshop and other great photo editing applications.

Photoscape

It is free and a very great photo editing software. It enables you to create slideshows and animated GIFs, combine and split images, and capture screen shots too.

Fotor

This photo editing tool is fairly easy to use. On its home screen, you are provided with three choices which include editing a photo, designing a card, or making a collage. You will also be able to add border effects and changing the theme. You do not need to be a guru in photo editing to use this application.

iPiccy

It can easily be used with Microsoft paint. The editing process is automated. It gives you the option of fixing images, resizing, cropping, rotating, flipping, and changing the exposure. The only disadvantage is that it has no undo button.

Pixlr.com

This application is sub-divided into three. There is the pixlr editor (advanced), pixlr-o-matic (playful) and pixlr express (efficient). It has mobile applications for smartphones and can be downloaded for android and iOS. Pixlr editor is straight forward, express lets you play with your creative side, and pixlr-o-mantic just lets you play with effects on your photo.

Serif photo plus

This application is a free version of the paid software. It has all the basic features that are common in photo editing. However, as you would expect there are certain features available in the paid version that are missing. It may have been created to entice you to buy the paid version if you wish to enjoy more features.

Chapter 8. 5 Basic Photo Editing Tips

Having looked at some of the best photo editing applications, you will need to learn a few tricks that go into photo editing. If you are to learn these tricks on your own, it would take you several days and it is no guarantee that you would have gotten most of them. These five are the most basic and apply to majority of the commonly-used tools.

Use of clarity

This should be used when adjusting skin tones in portraits. Clarity should be increased when adding some masculine roughness and it should be decreased when you want to soften skin tones. By doing so, you will be able to achieve an appealing finish on your photography.

Vibrance over saturation

Achieving a great image without affecting the skin tone of the people in the picture can be achieved by increasing vibrance more than saturation. This can be attribute to the fact that vibrance works well cool colors like blue and green whereas saturation on the other hand is better off with warm colors such as

yellow and red. The best way to balance them would be to increase vibrance 3 times the amount of saturation.

If you have a blue sky that is too bright, you can have it taken care of by simply adjusting luminance. On the HSL panel, you will find luminance where you will click adjust and place it at top of the sky and the n drag. It is as simple as that and you will have your great-looking blue sky staring back at you.

The graduated filter

This can be used to add weight to lower part of a photo. First you have to select the graduated filter then set the exposure to around -33. Click at the bottom of the picture and drag to half. It should give your image a natural look and give it some bit of density.

Adjusting shadows

Shadows on a picture can easily be adjusted by going to the tone curve panel. Fix the shadows settings to about -10 and the darker ones to +10. This will help improve the contrast on the overall outlook of the image. This feature will save you a great deal of time

considering the fact that mastering the art of handling light is very hard. Without this feature, you may be forced to do many retakes just to get it right.

Adding richness to the image

This one should be a bonus because there are just too many tricks around. Blacks can be boosted to about +5 points. A deeper color always looks sharp and gives your image a great look. It makes it distinct.

The photo editing techniques can be grouped into stages where we have the beginner's stage, the intermediate, and then the professional. From background changing, image sharpening, skin retouching, to whitening teeth, there is nothing that cannot be achieved with the use of the right software application. Whatever your preference is, it is as easy as a few clicks and drags here and there.

Chapter 9. Photo Shoot Techniques

This is about photography tricks like observing the backlight, placing the person or object at right place etc. that will make you take better photos

As we have seen above, taking great pictures requires more than just an expensive camera. It takes a great eye to see through the finer details. With time most of these techniques become easy to master. It would take a few trials and error but it would be worth it in the end. Furthermore, whatever they say about experience being the best teacher is very true.

Use of window light

Not everybody can afford great home-studio lighting equipment. That does not mean that you cannot take stunning portraits. Natural light from the sun will do just fine. You should have reflector with you and a window that lets in light. The only challenge will be in positioning the model. They have to be at a certain angle to the window and a silver or white reflector used to undo the shadows across their face.

Group portraits

In this type of photo shoot, the most important things to consider are the height of the people in the group and the color of their attires. Taller people can be placed at the back while the shorter ones at the front. In terms of color of their attires, you have to take consider any color clashing incidences. Everyone has to appear sharp. An aperture of about f/8 having a wide lens will be appropriate. To deal with the issue of shutter speed, try arranging all the people in a line that is on the same focal plane.

Photographing wild life

This may be the hardest type of photography ever. This is because for one you want to take pictures of the animals while in their natural state and two, the animals such as birds are always on the move. Techniques that can be used in such instances include panning when shooting birds, using a spotting scope, and using of a monopod to get a better footing and avoid shaking.

Switch autofocus off

This should be done when you are shooting macro photos. Accurate focusing is very important when shooting close up details. The best way to achieve this would be to magnify the area on live view screen and positioning the lens focus screen on the area. In this case, you will definitely need a tripod because any movement of the camera will spoil the photo.

Light painting

This is done when you are shooting night scene pictures. In this case, you can use a torch or flash gun to paint the scene. The feature that has been light painted has to be bright but not burning out. The camera has to be set to bulb mode then you will need a lockable remote release. Its purpose would be keeping the shutter open when you are illuminating the subject to be photographed.

Remove UV filters

Still on night photos, you are advised to remove the UV filters or skylight filter that shield the lens. If it is not removed, it will cause formation of internal reflections. A lens hood would be a better alternative for

protecting the lens without affecting the quality of the image.

Conclusion

When venturing into professional photography, you not only have to learn how to take the photographs right but also invest time into choosing the right tools for the job. With digital photography, every shot, every magnification power, and most definitely all the lighting matters. To some people, choosing the right camera could be as simple as throwing lot with a reputable manufacturer. To others, there is a clear distinction in what different cameras on a specific range could do.

Moreover, understanding that digital photography is never about presenting the photo as you captured it will give you an upper hand in the market. Learning how to use editing tools to smoothen out those pimples and make the skin glow will make your portrait photos come to live. Knowing how to use Photoshop in enhancing the blur on a nature photo shoot will make that lion or tiger seem like it is about to pounce out of the frame and share a vigorous hug.

Thank You Page

I want to personally thank you for reading my book. I hope you found information in this book useful and I would be very grateful if you could leave your honest review about this book. I certainly want to thank you in advance for doing this.

If you have the time, you can check my other books too.

Lightning Source UK Ltd.
Milton Keynes UK
UKHW02f1822050118
315576UK00011B/663/P

9 781681 858715